Japanese Storefront
Coloring Book

Step into the enchanting world of Japan with the "Japanese Storefront Coloring Book." This unique coloring book offers 50 illustrations of diverse Japanese storefronts on single-sided pages, providing a delightful journey through the captivating charm of traditional Japanese architecture and the vibrant culture it represents. Immerse yourself in art of coloring as you bring these beautiful storefronts to life with your creativity.

manny books publishing

© 2023 Manny Books Publishing , All rights reserved.

Made in United States
Orlando, FL
23 March 2025